A Kid's Guide to Drawing America™

How to Draw
Mississippi's
Sights and Symbols

Jaycee Kuedee

The Rosen Publishing Group's
PowerKids Press™
New York

Published in 2002 by The Rosen Publishing Group, Inc.
29 East 21st Street, New York, NY 10010

First Edition

Book Design: Kim Sonsky
Layout Design: Dean Galiano
Project Editors: Jannell Khu, Jennifer Landau

Illustration Credits: Jamie Grecco except p. 18 by Emily Muschinske
Photo Credits: p. 7 © W. Cody/CORBIS; p. 8–9 (self-portrait, sketch, and painting) © Collection of Mississippi Museum of Art, Jackson/Photography by Steve Colson Commercial Photography; pp. 12, 14 © One Mile Up, Incorporated; p. 16 © Peter Smithers/CORBIS; p. 18 © Martin B. Withers; Frank Lane Picture Agency/CORBIS; p. 20 © Roger Tidman/CORBIS; p. 22 © Kennan Ward/CORBIS; p. 24 © Richard Cummins/CORBIS; p. 26 © Index Stock; p. 28 © Philip Gould/CORBIS.

Kuedee, Jaycee
 How to draw Mississippi's sights and symbols / Jaycee Kuedee.
 p. cm. — (A kid's guide to drawing America)
 Includes index.
 Summary: This book explains how to draw some of Mississippi's sights and symbols, including the state seal, the official flower, and the Biloxi Lighthouse.
 ISBN 0-8239-6080-3
 1. Emblems, State—Mississippi—Juvenile literature 2. Mississippi—In art—Juvenile literature 3. Drawing—Technique—Juvenile literature [1. Emblems, State—Mississippi 2. Mississippi 3. Drawing—Technique]
I. Title II. Series
 2001
 743'.8'99762—dc21

Manufactured in the United States of America

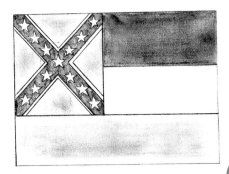

CONTENTS

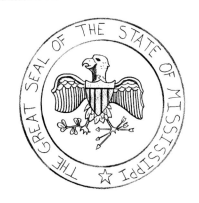

1	Let's Draw Mississippi	4
2	The Magnolia State	6
3	Mississippi Artist	8
4	Map of Mississippi	10
5	The State Seal	12
6	The State Flag	14
7	The Magnolia Flower	16
8	The Magnolia Tree	18
9	The Mockingbird	20
10	The Wood Duck	22
11	The Biloxi Lighthouse	24
12	The Mississippi River	26
13	Mississippi's Capitol	28
	Mississippi State Facts	30
	Glossary	31
	Index	32
	Web Sites	32

Let's Draw Mississippi

The land we call Mississippi once was populated mostly by Native Americans and buffalo. More than 8,000 years ago, Native Americans created a trail that crossed almost the entire state. This historic trail, or trace, between Nashville, Tennessee, and Natchez, Mississippi, now is known as the Natchez Trace Parkway.

The first nonnative men to cross the Mississippi River might have been Spanish explorer Hernando de Soto and his crew in 1540. About 150 years later, Pierre Le Moyne, a French Canadian naval officer, built a fort at the mouth of the Mississippi River. European settlers soon moved there and established towns.

The state's first industry was cotton. The use of slaves on cotton plantations in the South was one cause of the Civil War, which lasted from 1861 to 1865. In addition the South was not as tied to the U.S. government as the North was. Northern businesses depended on government-built roads and railways in a way that Southern businesses did not. This tension between the North and the South also led to war.

In this book, you will learn how to draw some of Mississippi's sights and symbols. You begin each drawing with a simple shape. Then you add other shapes. Directions under each drawing explain how to do the step. New steps are shown in red. Look at the list of drawing terms for the shapes and words used throughout the book.

You will need the following supplies to draw Mississippi's sights and symbols:

- A sketch pad
- An eraser
- A number 2 pencil
- A pencil sharpener

These are some of the shapes and drawing terms you need to know to draw Mississippi's sights and symbols:

3-D box

Almond shape

Horizontal line

Oval

Rectangle

Shading

Squiggle

Teardrop

Vertical line

Wavy line

The Magnolia State

Mississippi is named after the Mississippi River, which forms the state's twisting, western border. The name was first printed on a map drawn by French explorer René-Robert Cavelier de La Salle in 1695. La Salle had traveled down the Mississippi River to its mouth and had claimed the surrounding land for France. The name "Mississippi" is believed to have come from a Native American word meaning "the father of waters." Mississippi's official nickname is the Magnolia State, named for the magnolia tree and flower. The magnolia flower appears in several official state symbols. Towns and cities across Mississippi have adopted unofficial nicknames, too. Mississippi is home of the Catfish Capital of the World and the Sweet Potato Capital of the World. These are towns and cities that claim to produce more of these products than do any other places in the world. Along U.S. Route 90 in southern Mississippi is an area known as the Praline Capital of the World. It is famous for making the sugary candy called pralines.

This fireboat is traveling down the Mississippi River, the longest river in North America. Fireboats hold gear that helps put out fires.

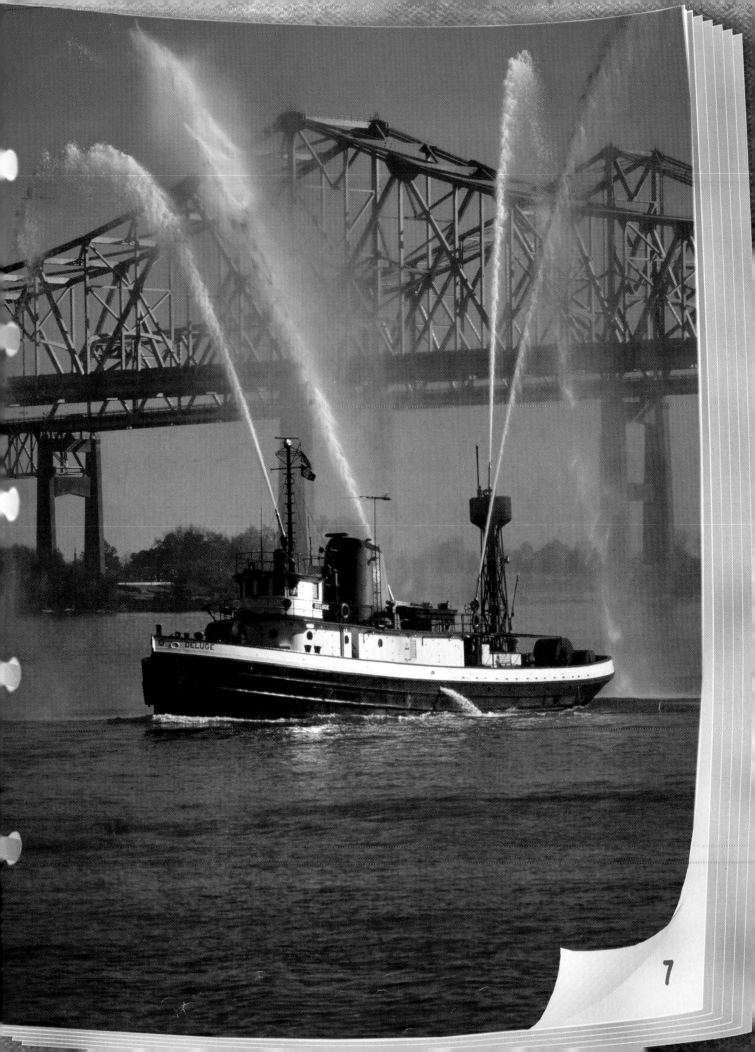

Mississippi Artist

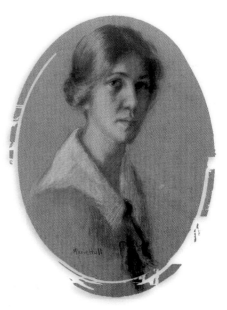

Marie Atkinson Hull is called the grandmother of Mississippi art because of her influence on Mississippi artists. Marie Atkinson was born in 1890 in Summit, Mississippi. In 1910, she began studying art with Aileen Phillips, the only art teacher in Jackson, Mississippi. Atkinson entered the Pennsylvania Academy of the Fine Arts in 1912. Her importance as an artist was recognized in 1916, when she was named president of the Mississippi Art Association. The following year, she married Emmett J. Hull, an architect for whom she made architectural

Marie Atkinson Hull drew this pastel portrait of herself.

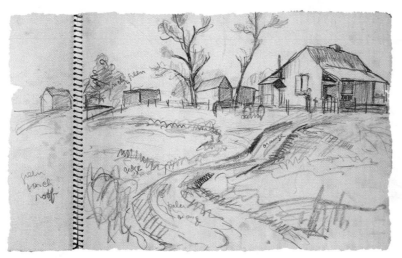

drawings. Hull traveled around the world to paint and to study the works of other artists. She stopped in France, Spain, Morocco,

Hull presented a rural Mississippi landscape in this graphite sketch of a farmhouse.

Canada, and Mexico. Her work included landscapes and still lifes in pencil, watercolor, and oil. During the Great Depression, when money was scarce, Hull also painted portraits to pay her bills. She won prizes for her art, including the Davis Prize in 1929, which gave her the chance to show her work at the Art Institute of Chicago. Through the years Hull became a mentor to many Mississippian artists. Her contributions were so great that in 1975, Governor William Waller named October 22 Marie Hull Day in the state of Mississippi. Marie Atkinson Hull died in 1980.

This untitled painting of a path through a thick woods was done in oil on paper.

Map of Mississippi

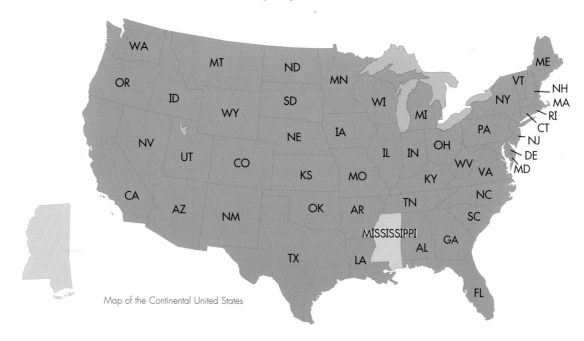

Map of the Continental United States

Mississippi is in the southeastern United States. It covers 48,286 square miles (125,060 sq km) of land and has a population of almost 3 million. Mississippi borders Tennessee, Alabama, Louisiana, and Arizona. The state's southernmost border is the Mississippi Sound in the Gulf of Mexico. Its western border is the Mississippi River. The river's tributaries help create an environment that is rich in plant and animal life. The state's national forests are DeSoto, Bienville, Tombigbee, Delta, Homochitto, and Holly Springs. Some of its national wildlife refuges include Yazoo, Panther Swamp, Mississippi Sandhill Crane, and Noxubee. The state's highest point is Woodall Mountain, only 806 feet (246 m) above sea level.

1

Start by drawing a vertical rectangle.

2

Using the rectangle as a guide, draw the shape of Mississippi. Add the shape below the rectangle as shown.

3

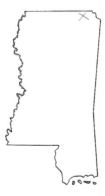

Erase extra lines, and draw an *X* to mark the site of the Battle of Corinth. Use a dotted line to map the Mississippi River.

4

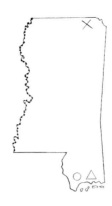

Draw in a circle to mark the city of Biloxi and a triangle to show the Gulf Islands National Seashore.

5

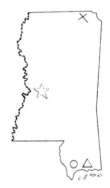

☆ Jackson
⋮ Mississippi River
✕ Battle of Corinth Site
◯ Biloxi
△ Gulf Islands National
 Seashore

To finish your map, draw a star to mark Jackson, the capital of Mississippi. Check the key in the upper right corner to make sure all the points of interest are included.

The State Seal

Mississippi gained statehood in 1817 as the twentieth state. The state continues to use the seal designed in 1798, when Mississippi was still a territory. The design uses the image of a bald eagle, a national symbol of strength and freedom. The eagle is proudly positioned in the center of the seal with its wings spread wide and its head held high. In the eagle's left claw are three arrows. Its right claw clutches an olive branch, which is a symbol of peace. On the eagle's chest is a shield bearing stars and stripes, like those found on the American flag. In the outer portion of the seal are the words "The Great Seal of the State of Mississippi." A star, thought to represent the state, appears at the bottom of the seal.

1

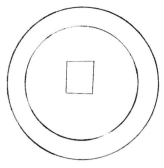

Start by drawing a large circle, then add a smaller circle inside it. Draw a square in the center of the smaller circles for the shield.

2

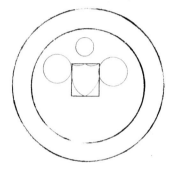

Add a circle on the left and the right sides of the square for the eagle's wings. Add a small circle above the square for the head. Draw the shape of the shield in the square.

3

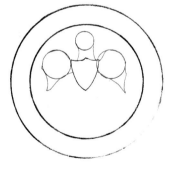

Erase extra lines. Use the circles to guide you as you draw in the eagle's neck and wings.

4

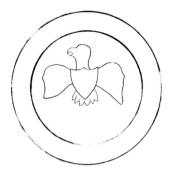

Erase extra lines, and add the eagle's beak and its tail.

5

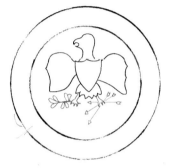

Draw the eagle's feet. Add triangles and straight lines for arrows and oval-shaped leaves on a curved line for the olive branch.

6

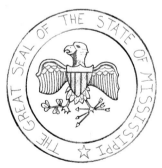

Add the words "THE GREAT SEAL OF THE STATE OF MISSISSIPPI" around the outer portion of the circle, and add a star. Add as much detail and shading as you want. You also can draw the eagle's feathers and the stripes in the shield.

The State Flag

The official state flag of Mississippi was adopted in 1894. It is divided into three stripes, which are blue, white, and red. In the flag's upper left corner, there is a red square with a blue X. Inside the blue X, there are 13 white, five-pointed stars. These stars represent the first 13 states of the United States. To some the flag is a sad reminder of slavery. To others it is a symbol of unity for the state and honors those who died fighting the Civil War. In April 2001, Mississippians voted to decide whether to keep the 1894 flag or replace its Confederate symbol with a circle of white stars. The majority of the people voted to keep the 1894 flag.

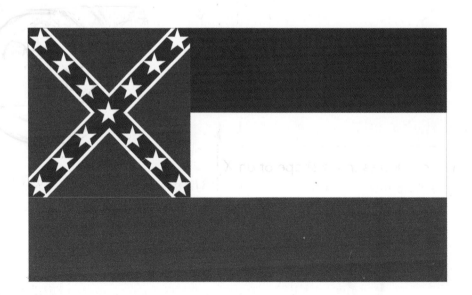

1

Start by drawing a large rectangle for the flag's field with a square in the flag's upper left corner.

2

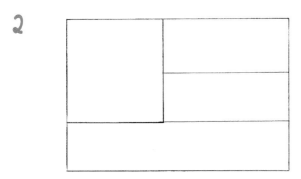

Divide the rest of the flag into three parts using two horizontal lines.

3

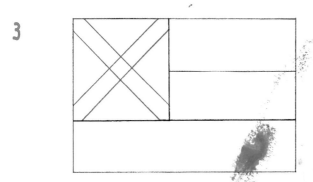

Add two thin rectangles in the shape of an *X* in the upper left corner.

4

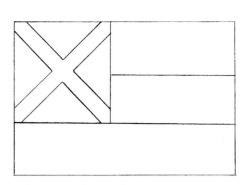

Erase extra lines and smudges.

5

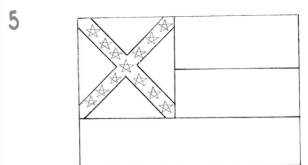

Draw 13 stars in the two thin rectangles.

6

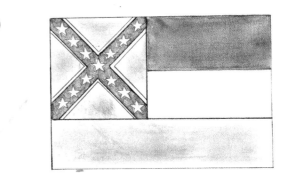

Erase extra lines. Add detail and shading or color your flag, and you're done.

The Magnolia Flower

An election was held in November 1900, to select a state flower for Mississippi. More than 23,000 schoolchildren voted to choose the state flower. The magnolia flower received more votes than did any other flower. It was not until 1952, however, that the magnolia flower became the official state flower. Magnolias blossom in the spring and summer, and they are known for their beautiful, strong scent. The flower is white and cup shaped. It can be from 6 to 8 inches (15–20 cm) in diameter. When the magnolia bud is closed but near blooming, its petals have a purple tinge. The magnolia is both Mississippi's official state flower and its state tree. No other state can make this claim.

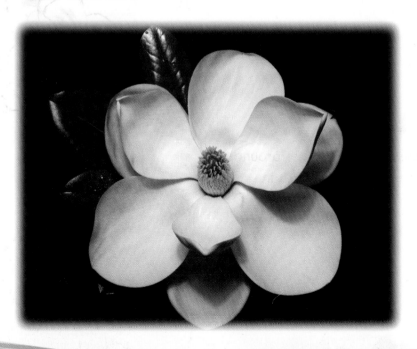

1

Start by drawing a circle for the center of the flower. Then draw four circles around the center for the first layer of petals.

2

Add four, slightly larger, half circles around the first four circles for the second layer of petals.

3

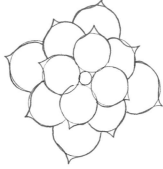

Draw four more large half circles around the second layer of petals to finish the flower's basic shape.

4

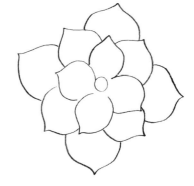

Start drawing in your petals by adding the curved shapes as shown. Use the circles as guides.

5

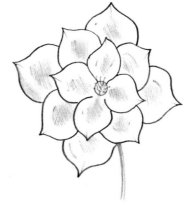

Erase extra lines.

6

Add shading and detail to your magnolia flower. You're done!

The Magnolia Tree

In 1938, Mississippi named the magnolia (*Magnolia grandiflora*), a tree native to Mississippi, its official state tree. The magnolia has gray or light brown bark that is broken into small, thin scales. Oblong leaves with short points and smooth edges line the tree. The leaves have a leathery feel and are usually from 5 to 8 inches (13–20 cm) long. Cup-shaped, fragrant, white flowers blossom on the magnolia, and conelike fruit hang from its branches. The fruit are reddish brown, thick, and hairy. They can be from 3 to 4 inches (8–10 cm) long and from 1 to 2 inches (2.5–5 cm) thick. A magnolia tree can grow to be very large and requires plenty of room to spread its branches.

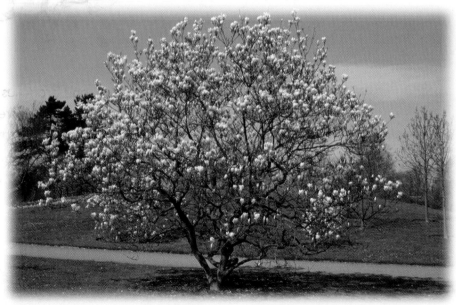

1

Begin by drawing a small, upside-down triangle. On top of the triangle add a large oval, or bean shape. These two shapes will guide you as you draw the tree.

2

Now draw the tree's trunk using curved lines. It divides into thick branches that reach toward the top of the oval.

3

Add thin, crooked branches.

4

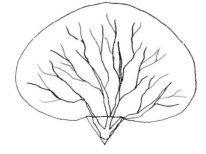

Add more small, crooked branches.

5

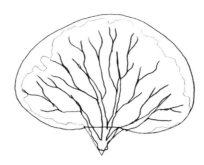

Using the oval to guide you, draw a fluffy outline of the leafy top of the magnolia tree.

6

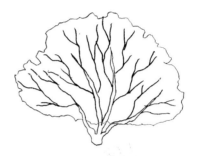

Erase your guides. Finish the bottom of the fluffy outline.

7

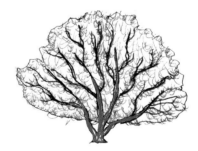

Shade the trunk and branches of your tree. Use repeated wavy lines to create the surface of the bark. To finish your drawing shade the leafy top of the tree. Use lots of squiggly lines to create the texture of leaves and flowers.

The Mockingbird

The mockingbird became the state bird of Mississippi in 1944. Mockingbirds have the amazing ability to imitate not just other birds, but barking dogs, notes from a piano, and even squeaky door hinges! When they're not copying the voices of others, mockingbirds sing a rather sad song. Male and female mockingbirds share certain jobs, such as building the nests in which they will live for many years. Their eggs are blue, green, or a combination of the two colors. When the babies hatch, both parents are very protective. They will swoop down and attack cats or people to defend their young. Mockingbirds have mostly gray backs and a pale gray-and-white underbelly. Their wings are gray, black, and white.

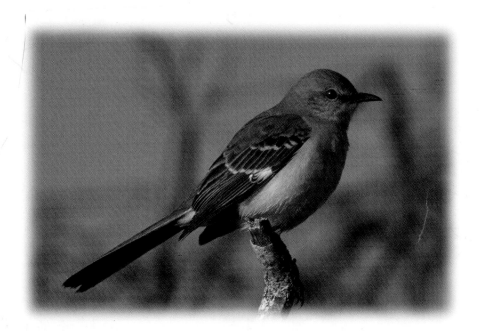

1

Start by drawing three circles for the rough shape of the mockingbird's body and head.

2

Connect the circles to form the shape of the mockingbird's body. Add a thin rectangle at the left of the smallest circle for the tail.

3

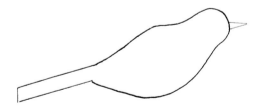

Erase extra lines and add a small triangle for the beak.

4

Draw a triangle for the wing, a small rectangle for the top of one of the legs, and a squiggly line for the tip of the tail.

5

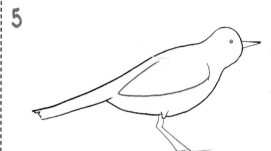

Erase extra lines, and draw the legs, the feet, and an eye. Draw in the shape of the wing.

6

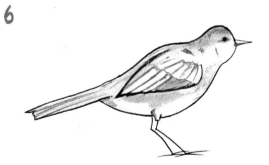

Add shading and detail to your mockingbird, and you're done. You also can smudge the lines to give the shading more depth.

The Wood Duck

The wood duck (*Aix sponsa*) was named Mississippi's official state waterfowl in 1974. The wood duck has many beautiful colors. It has a green head with white stripes, a reddish neck, and a white underbelly. The coloring on its back is a combination of green, blue, purple, and bronze. Adult wood ducks are from 17 to 20 inches (43–51 cm) long and live in ponds, lakes, and streams. They eat insects, worms, acorns, plants, and crustaceans. If the food they want is underwater, wood ducks dive under the surface, causing their tails to pop out of the water. Wood ducks don't quack like other ducks. Their alarm call is a loud "whoo-eek," and their flight call sounds like "jeee jeee."

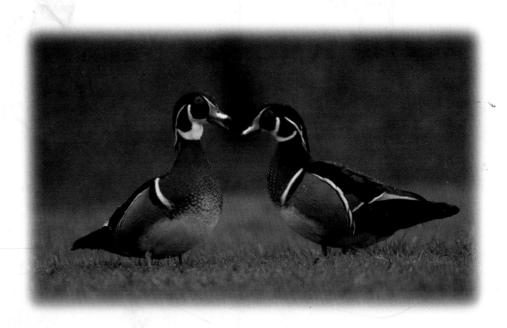

1

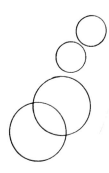

Start by drawing four circles for the rough shape of the wood duck. Notice the different sizes.

2

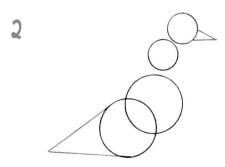

Add a large triangle for the tail and a small triangle for the beak.

3

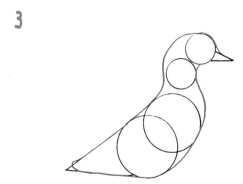

Using the circles and the triangles as a guide, draw the shape of the wood duck.

4

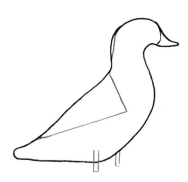

Erase extra lines. Add one triangle for the wing and two thin rectangles for the legs. Add detail to the back of the head.

5

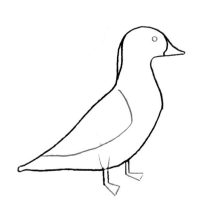

Add triangles for the feet and a circle for the eye. Draw a curved line around the triangle to create the wing. Erase extra lines.

6

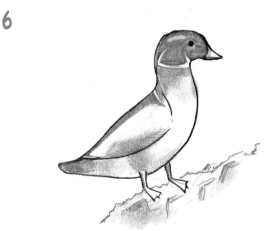

Add shading and detail to your wood duck, and you're done. You also can smudge your lines to make the shading more effective.

The Biloxi Lighthouse

The Biloxi Lighthouse, outside of Biloxi, Mississippi, was built in 1848. This cone-shaped building is 65 feet (20 m) tall. The light is still in use, helping ships sail safely through the Gulf of Mexico and Biloxi Bay. The Biloxi Lighthouse is the only lighthouse in existence that stands in the middle of a four-lane highway that runs along the world's longest human-made beach.

Biloxi is one of the oldest communities in the Mississippi Valley. In 1699, the French established a settlement here and named it for the Biloxis, who were Native Americans living in the area. Today the city of Biloxi is a year-round resort and a fishing center.

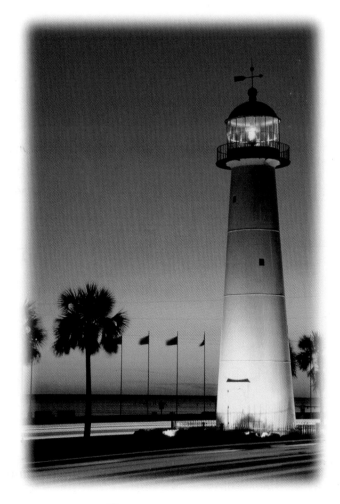

1

Start by drawing a long, squared-off triangle for the basic shape of the lighthouse.

2

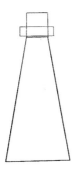

Add two rectangles to the top of the lighthouse. Notice how they connect.

3

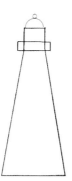

Next draw a half circle with a small circle on top of it to complete the roof.

4

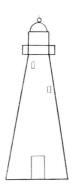

Use two rectangles for the windows and one for the door. Add a small vertical line for the peak of the roof.

5

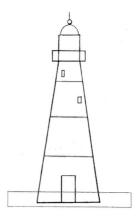

Draw three horizontal lines across the lighthouse. Add a rectangle at the bottom for the fence around it.

6

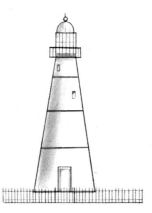

Finish your fence with short vertical lines for bars. Add shading and detail to your lighthouse, and you're done.

25

The Mississippi River

The Mississippi River is the longest river in North America. It flows from Lake Itasca, in Minnesota, to the Gulf of Mexico, a distance of 2,340 miles (3,766 km). Since the nineteenth century, the river has been an important, economic resource for the United States. However it also poses a real danger when it floods. The flood of 1927 was the worst in the history of the lower Mississippi Valley. It killed more than 200 people and caused property damage worth about $1.5 billion in today's prices. Today the Mississippi Drainage Basin, an area that covers more than 1,245,000 square miles (3,224,535 sq km) of land, helps to prevent floods along the Mississippi River.

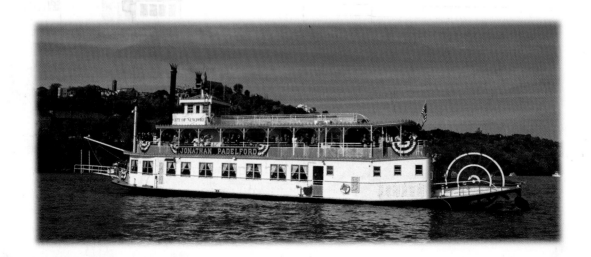

1

To draw a Mississippi riverboat, start by drawing three rectangles for the front of the boat. Notice that the bottom rectangle's side is slanted.

2

Add three more rectangles for the rear of the boat, and one long horizontal line on top of the boat.

3

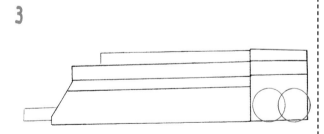

Draw two circles for the paddle and another small rectangle in front of the boat.

4

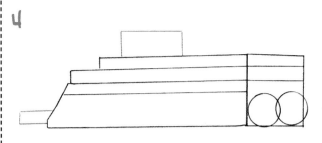

Draw a rectangle on top of the boat for the control room.

5

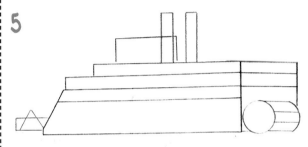

Add two rectangles for smokestacks and a triangle to the front of the boat. You also can connect the circles using short, straight lines to form the paddles. Erase extra lines.

6

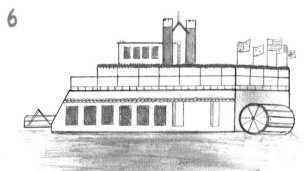

Use small rectangles for windows and doors. Add shading and detail to your steamboat, and you're done. You also can add water and flags for extra detail.

Mississippi's Capitol

Construction for the current Mississippi state capitol in Jackson began in 1901. The building was completed in three years. The old building had become too small for Mississippi's growing state government. Theodore Link, an architect from St. Louis, Missouri, designed Mississippi's new capitol in the beaux arts classical style. Made from granite and limestone, the capitol was built on the site of the old state prison. A huge dome rises from the second floor on four piers to a height of 180 feet (55 m) above ground level. The eagle perched on the top of the dome is made of copper and coated in gold leaf. To mark the first day of each legislative session, all the 4,750 lights in the capitol building are turned on.

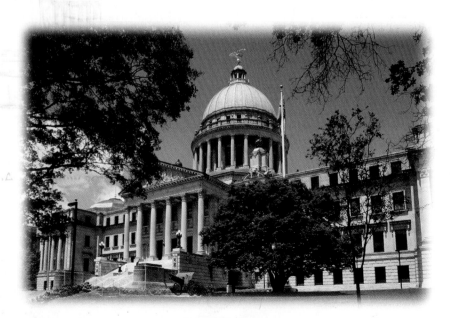

1

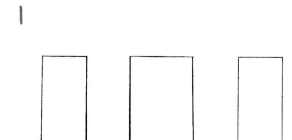

Start by drawing three rectangles for the building's wings.

2

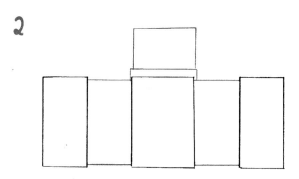

Add two more rectangles to finish the front of the building. Then add two rectangles for the base of the dome.

3

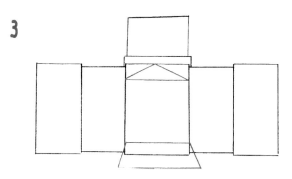

Draw a rectangle with slanted sides for the stairs and a triangle for the top of the main entrance.

4

Over the top, center rectangle, draw a half circle. Then draw a small circle for the dome.

5

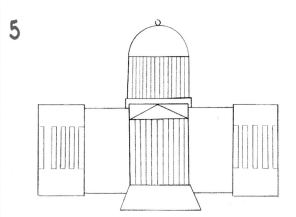

Add all of your columns using thin rectangles.

6

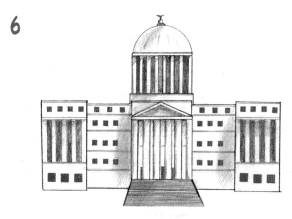

Use small squares for windows. Add shading and detail to your building, and you're done.

Mississippi State Facts

Statehood	December 10, 1817, 20th state
Area	48,286 square miles (125,060 sq km)
Population	2,768,600
Capital	Jackson, population, 192,900
Most Populated City	Jackson
Industries	Real estate, health services, electronic equipment, banking, and forest products
Agriculture	Eggs, poultry, cotton, catfish, cattle, rice, soybeans, and dairy products
Animal	White-tailed deer
Bird	Mockingbird
Flower	Magnolia flower
Fish	Largemouth bass
Motto	By Valor And Arms
Tree	Magnolia
Gemstone	Mozarkite
Insect	Honeybee
Marine Mammal	Bottle-nosed dolphin
Mineral	Prehistoric whale
Song	"Go Mississippi"
Butterfly	Spicebush swallowtail
Nickname	The Magnolia State

Glossary

architect (AR-kih-tekt) Someone who designs buildings.

basin (BAY-sin) An area of land on either side of a river.

beaux arts classical (BOH ZARTS KLA-sih-kuhl) A style of art using historic ornaments, decorations, and rich details.

Civil War (SIH-vul WOR) The war fought between the northern and southern states of America from 1861 to 1865.

Confederate (kuhn-FEH-deh-ret) Relating to the group of people who made up the Confederate States of America.

crustaceans (kruhs-TAY-shunz) Small creatures that live in the sea.

diameter (dy-A-meh-tur) The measurement across the center of a round object.

fragrant (FRAY-grint) Something that smells.

granite (GRA-niht) Melted rock that cooled and hardened beneath Earth's surface.

Great Depression (GRAYT dih-PREH-shun) A period of American history during the late 1920s and early 1930s. Banks and businesses lost money and there were few jobs.

industry (IN-dus-tree) A system of work, or labor.

limestone (LYM-stohn) A rock that is formed from shells and skeletons.

majority (muh-JOR-ih-tee) More than half.

mentor (MEHN-ter) A trusted counselor or guide.

oblong (AH-blong) A long, oval shape.

plantations (plan-TAY-shunz) Very large farms where crops are grown and harvested.

tributaries (TRIH-byoo-tehr-eez) Rivers or streams that flow into a larger river.

Index

B
Biloxi Lighthouse, 24

C
capital, 6
capitol, 28
catfish, 6
Civil War, 4
cotton, 4

G
Gulf of Mexico, 10,
 24, 26

H
Hull, Mary Atkinson,
 8–9

J
Jacksonville,
 Mississsippi, 8, 11, 28

L
La Salle, René-Robert
 Cavelier de, 6

M
magnolia tree, 6, 16,
 18
Mississippi River, 4, 6,
 10, 26

N
national forests, 10
Native Americans, 4,
 24
nicknames, 6

S
Soto, Hernando de, 4
state bird, 20
state flag, 14
state flower, 16
state seal, 12
sweet potato, 6

W
wood duck, 22

Web Sites

To learn more about Mississippi, check out this Web site:
www.state.ms.us